LES CHIENS
de Paris

{ Dogs in Paris }

BARNABY CONRAD III

CHRONICLE BOOKS

SAN FRANCISCO

FOR MILLY, GERI, AND
ROLAND, WITH LOVE

Printed in Singapore.

Book and cover design:
Jilly Simons, Concrete, Chicago

Library of Congress Cataloging-in-Publication Data:
Conrad, Barnaby, 1952–
Les Chiens de Paris / [compiled] by Barnaby Conrad III.
p. cm.
ISBN 0-8118-0743-6
1. Photography of dogs. 2. Photography, Artistic.
3. Dogs—Pictorial works. 4. Paris (France)—Pictorial works. I. Title.
TR729.D6C66 1995
779.32—dc20 94-19721
 CIP

Distributed in Canada by Raincoast Books
8680 Cambie Street
Vancouver, B.C. V6P 6M9

10 9 8 7 6 5 4

Chronicle Books
85 Second Street
San Francisco, CA 94105

Web Site: www.chronbooks.com

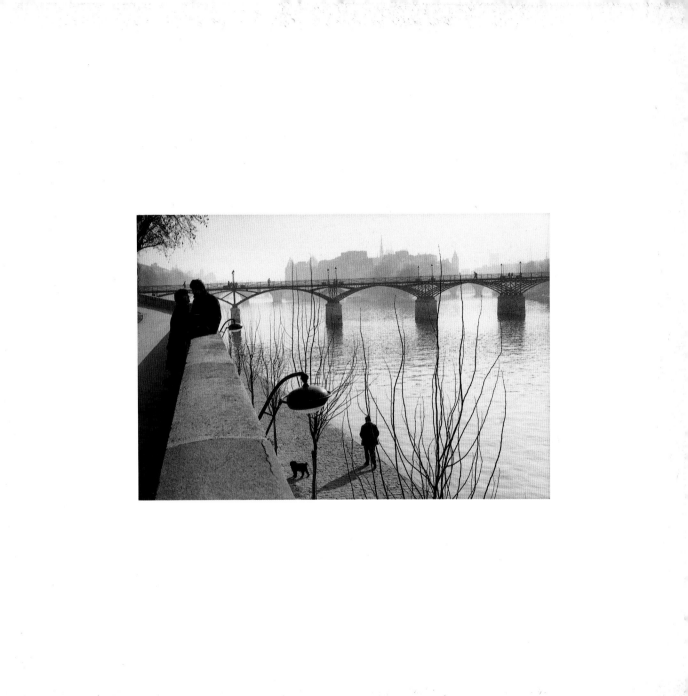

INTRODUCTION

PLUS JE VOIS L'HOMME, PLUS J'AIME MON CHIEN. Any Paris visitor who has witnessed the occasionally brusque manner of its citizens might embrace Pascal's acerbic remark: "The more I see of man, the more I love my dog." Certainly one is struck by the Parisians' penchant to treat their dogs more kindly than their fellow citizens. The canine population of France is almost 10 million—one dog for every five citizens—with Paris accounting for 200,000 dogs. "Dogs resemble the nation which creates them at least we suppose so," said Gertrude Stein in 1940. As a longtime resident of Paris, she observed that "Dogs are certainly like the people that own them and have them with them all the time." Rich and poor, old and young, the Parisians are so deeply linked to their dogs that were their pets suddenly to disappear, Paris itself would be changed. They're everywhere. Get into a Parisian taxi and your driver's co-pilot may turn out to be a drooling German shepherd. About one in seven cab drivers in the City of Light ride with their dogs—partly for company, partly for protection. When a driver with a Doberman advised me not to make any sudden movements while paying the fare, I knew it unnecessary to inquire *à la* Inspector Clouseau: "Dez your diggy bite?" For the most part the diggies don't bite, but the official French government estimate is half a million injuries from dog bites every year. Nevertheless, well-mannered dogs appear in hotel elevators, law offices, beauty parlors, flower shops, and on the Metro, where they ride *gratuitement*. One finds them sitting patiently under the tables of cafés, and dogs dine regularly at Maxim's. The better restaurants prefer to serve clients with well-behaved dogs rather than with restless children. Some still list a canine meal at the

bottom of the menu: *Repas de Chien: Viande garnie 5 Francs, Service non compris.* The few places that restrict canines are museums, shops that sell food (according to a law that is rarely enforced), certain children's playgrounds (enforced mainly by nannies, not *gendarmes*), and Père LaChaise Cemetery, which has a large feral cat population and enough bones to drive a dog mad with desire. A mutt once got loose in the graveyard, dug up a human femur, and eluded the authorities during an hour-long chase that went from Edith Piaf's monument to the tomb of rock star Jim Morrison, back to Marcel Proust's slab, and finally out through the main gates. *Quel chien!* Aldous Huxley meant it universally when he said, "To his dog, every man is Napoleon; hence the constant popularity of dogs," but it does seem to apply specifically to the French. For the lonely, dogs are substitutes for children, spouses, and even lovers. Writing in her 1940 memoir, *Paris France*, Miss Stein observed, "Dogs which are not useful dogs are a pastime, as one woman once said to me, one has a great deal of pleasure out of dogs because one can spoil them as one cannot spoil one's children. If the children are spoiled, one's future is spoilt but dogs one can spoil without any thought of the future and that is a pleasure." Today Parisian dog sitters charge $10 an hour—more than it costs to baby-sit infants—while twenty-four-hour veterinary clinics respond to pet crises with special ambulances equipped with oxygen tanks. The Parisian dog fetish has its disadvantages, particularly for pedestrians who must weave their way along the narrow *trottoirs* (sidewalks) scattered with *crottes* (crap). Some people have renamed the sidewalks *crottoirs.* One day I was walking in the Rue Dauphine when I came upon a woman ministering to what looked like a badly taxidermed marmot on a leash. The over-fed mongrel had assumed a quivering stance directly in my path. "Madame," I asked, "why are you doing this where everyone

walks?" She glared at me with indignation and snapped, "I pay my taxes, and besides, I'm in a hurry!" A completely Parisian response. 🐕 L'Hotel de Ville (city hall) is well aware of the problem. Here and there on the sidewalks they've stenciled a dog's profile and an arrow urging owners to aim their dogs into the gutters. Few heed the order. In 1992 Paris passed a "pooper-scooper" law, announced fines of up to $250, and sent fifty plainclothes sanitation agents to patrol the streets. Few Parisians took them seriously. Weren't there more heinous crimes to worry about? 🐕 Rather than attack the canine offenders head on, the French inventively work around the problem: Special sanitation employees dressed in green jumpsuits cruise the streets on motorcycles equipped with storage tanks and suction devices. 🐕 Although Paris hasn't yet established a dog museum, there is a dog cemetery. La Cimitière des Chiens is located at Asnières, outside of Paris on the Ile des Ravageurs. Founded in 1899, the necropolis by the Seine holds the pets of the famous, such as of Edmond Rostand, author of *Cyrano de Bergerac*; of the nineteenth-century painter Carolus Duran; of Cleo de Mérode, mistress of the king of Belgium; and of dramatist Sacha Guitry. Here one finds tombstones honoring such loyal pooches as: "'Drag,' 1941-53, Faithful Companion of Tragic Hours, Precious Friend in Exile, H. M. Queen Elizabeth, Princess of Romania." Epitaphs echo Pascal's quip, such as: "One would have thought he was human, but he was faithful!" And the touching, "Deceived by the world, never by my dog." 🐕 Photographer Elliot Erwitt, well known for his humorous books on dogs, commented: "Dogs are much more formal in Europe. In France, for example, the dogs are more intellectual than in America. They know they're part of the social fabric. You can see it in their expressions. They are also very territorial, in a specifically bourgeois way. They are confident that it is their butcher

shop, or café, or country estate, and ever will be. ❧ "I've never found French dogs to be overly generous, and they certainly have no sense of humor. The French dog owner shares his pet's high opinion of himself." ❧ Since the seventeenth century the French have been addressing the adored pooch as *Toutou*, an onomatopoeic nickname supposed to suggest a dog's bark. (By the way, a modern French dog says, *Wouah! Wouah!*, never "Woof-Woof.") Charlemagne's *toutous* were briards, an ancient breed of long-haired, muscular sheep dogs from the region of Brie. The hounds of Louis XIV were painted by François Desportes, and the paintings hang in the Louvre. Napoleon was fond of his poodle, Moustache, which accompanied him to the battles of Marengo and Austerlitz. He wasn't so fond of Josephine's pug, which occasionally went for the emperor's ankle. The Hotel des Invalides displays, along with the emperor's tomb, the dog who was his companion during the exile on Elba—stuffed for posterity. ❧ During the Franco-Prussian War of 1871, when Napoleon III was held captive in Kassel, Germany, his wife's dog, Linda, reportedly delivered messages from the empress. Linda's heroism notwithstanding, during the Siege of Paris, some Parisians were reduced to eating dog meat, which was sold at 2.5 francs a kilo. Novelist Émile Zola owned a black Pomeranian named Sir Hector Pinpin, which was said to have died of grief when its master fled to England in 1898 after being accused of libel for reporting the Dreyfus case. The dog was "simply incapable of living away from his master," said Zola's sister. ❧ The poodle is the dog most often associated with France. This *toutou* has been drawn by Durer, sculpted in bronze by Houdon, caricatured by Daumier, and engraved by Gavarni. Louis XV's poodle Filou was honored by painter Jean-Baptiste Oudry. ❧ The poodle reached its peak of popularity during the Victorian era. One reason was that its long bushy fur could be cut

and stylized to suit changing fashions, and during the 1860s, poodles were sometimes dyed red, blue, or purple. In her wonderful book *The Beast in the Boudoir* (1994), Kathleen Kete noted the true story of Victor Hugo, who in a moment of perverted generosity, gave away his beloved old poodle named Baron to a visiting Russian count. Baron, unable to live without his master, left Moscow and trotted a thousand miles back to Paris for a tearful reunion with Hugo. ❧ Today France's Société Central Canine registers 150,000 purebred puppies each year in the Livres des Origines Francaises (LOF). Up until a few years ago, French dogs were nose-printed for identification; now they are tattooed. A bit of good news is that the number of abandoned dogs has dropped from 400,000 in 1976 to just 40,000 today. After the German shepherd, the most popular breeds are the Yorkshire terrier, the Labrador retriever (favored by President Mitterrand, former leader Giscard d'Estaing, and designer Hubert de Givenchy), the Siberian husky, and the dachshund, while the French poodle ranks only ninth. The most fashionable dogs now are the West Highland terrier and the Cavalier King Charles. ❧ Great photographers have long been fascinated by the Parisian passion for dogs. This book begins with a touching photograph of a boy and his dog taken by Nadar in 1865, and goes on to portray nearly a century and a half of human and canine symbiosis. Big hounds, high-strung purebreds, and jaunty mongrels are framed by Jacques Henri Lartigue in parks, Marc Riboud in the circus, Elliot Erwitt in cars, Robert Doisneau in cafés, and Henri Cartier-Bresson on barges. Even as automobiles replace carriages and miniskirts overtake corsets, the timeless images of dog and master resonate with comedy, sadness, and *joie de vivre*. And in every picture there is the unspoken possibility of a past or future life in Paris.

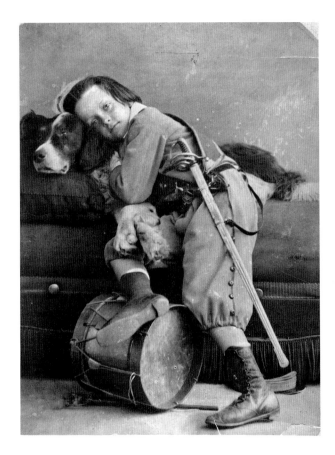

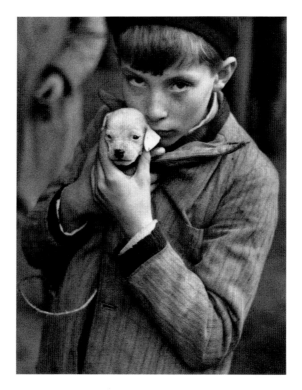

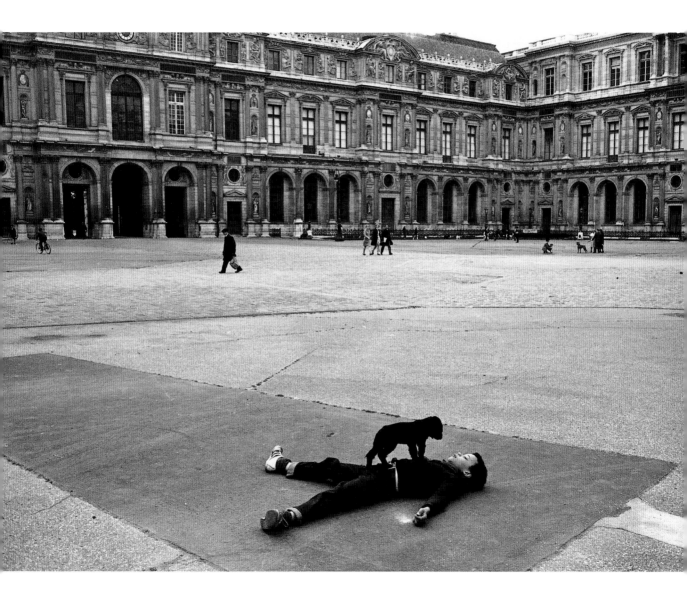

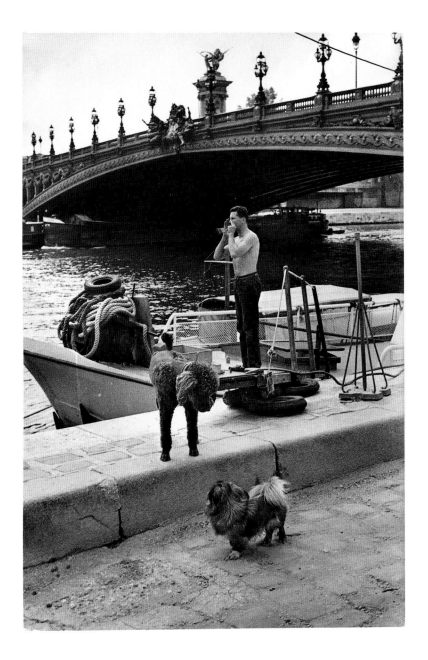

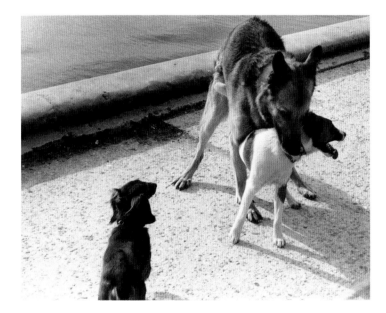

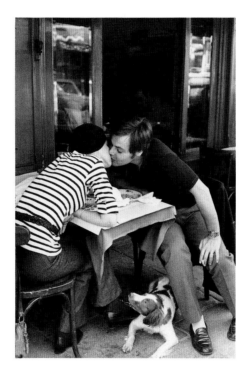

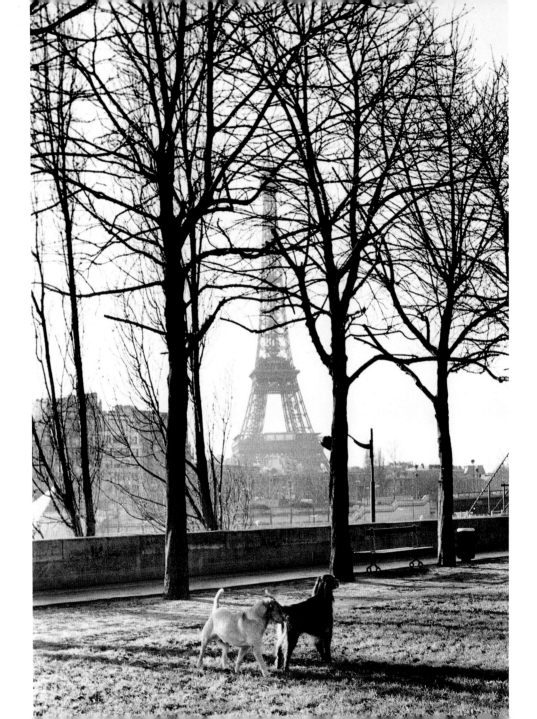

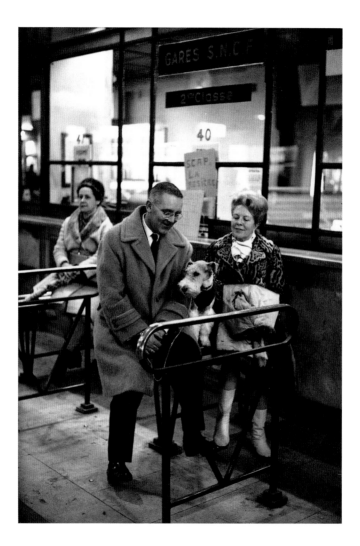

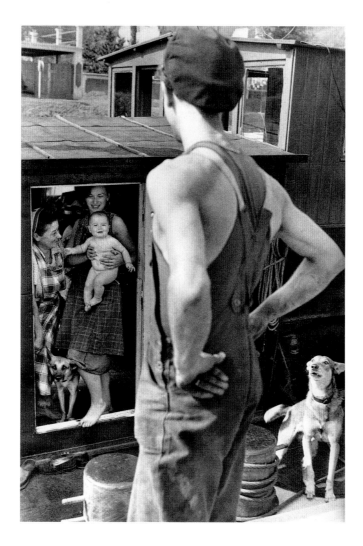

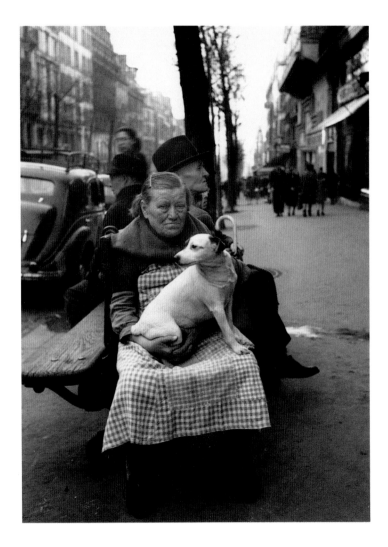

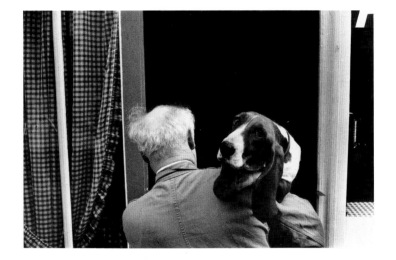

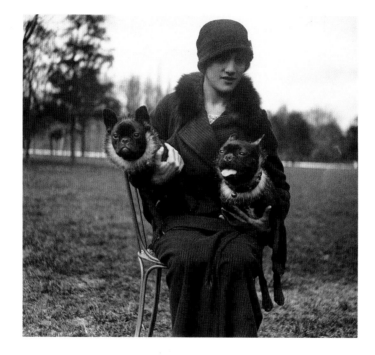

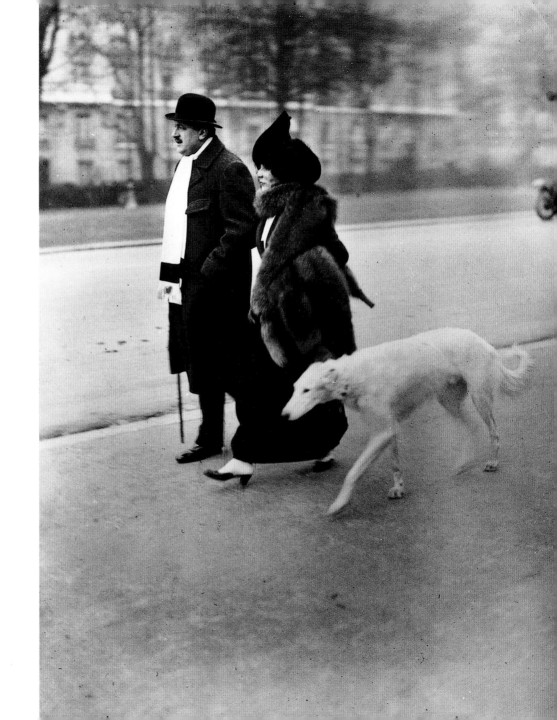

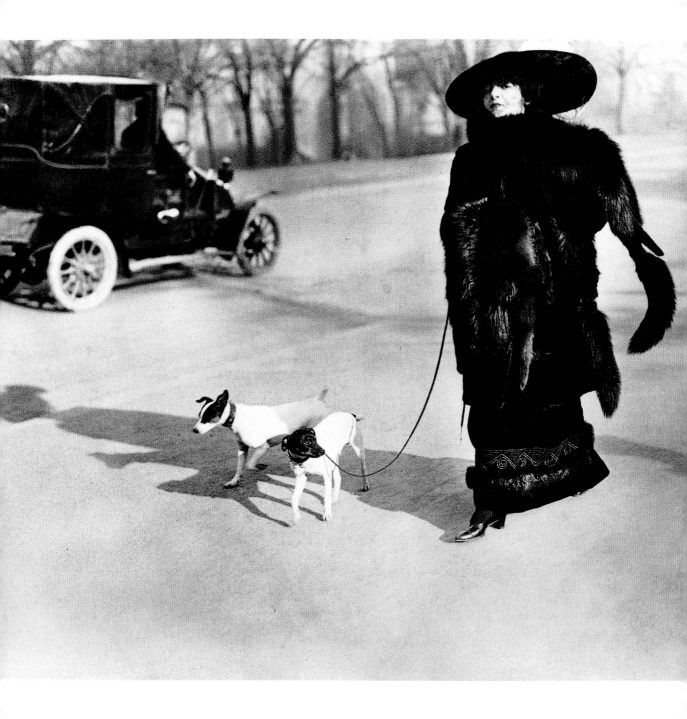

THE MORE
I SEE OF MAN,
THE MORE
I LOVE MY DOG.
{ Pascal }

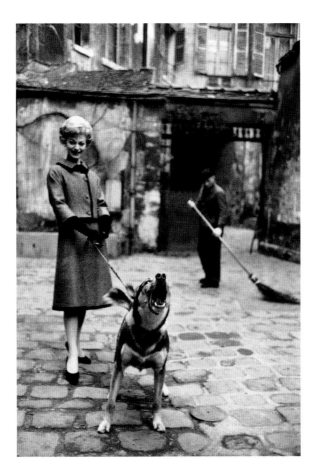

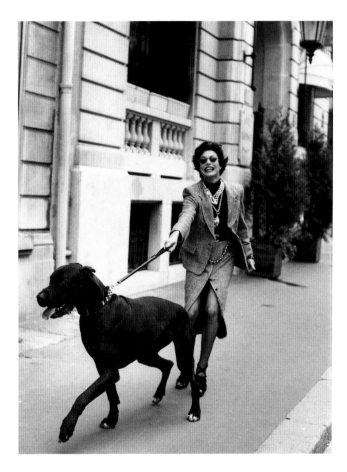

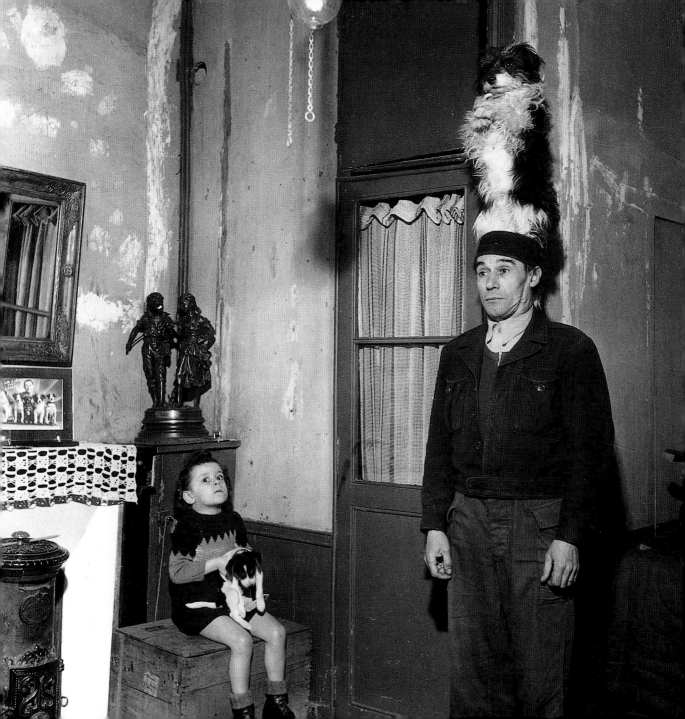

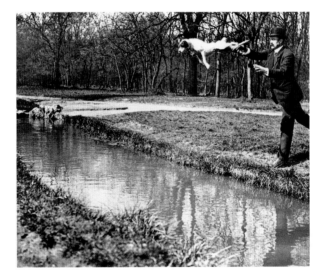

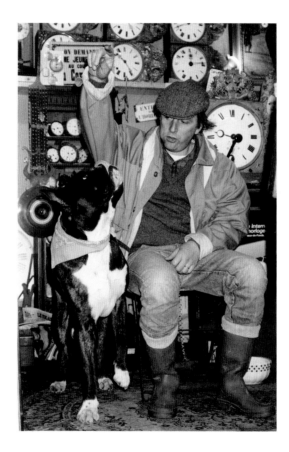

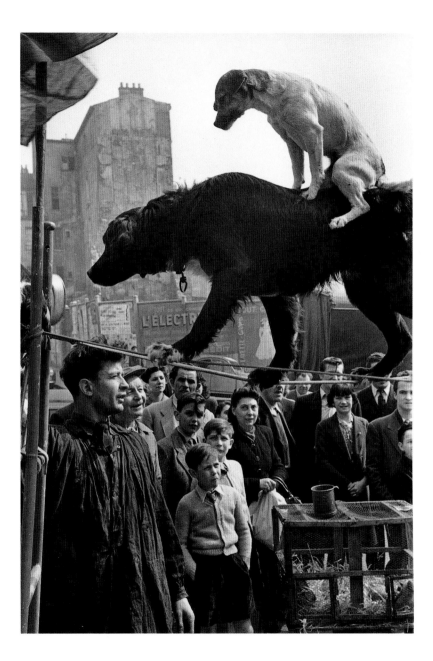

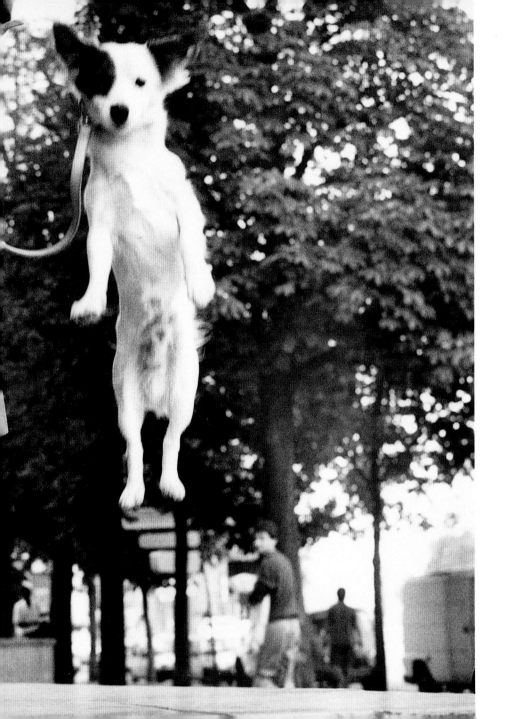

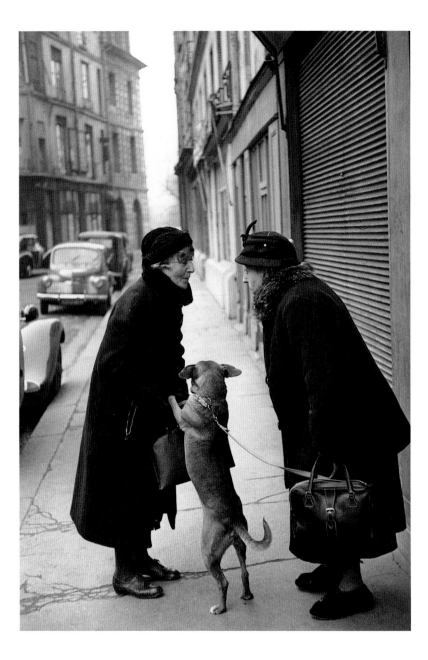

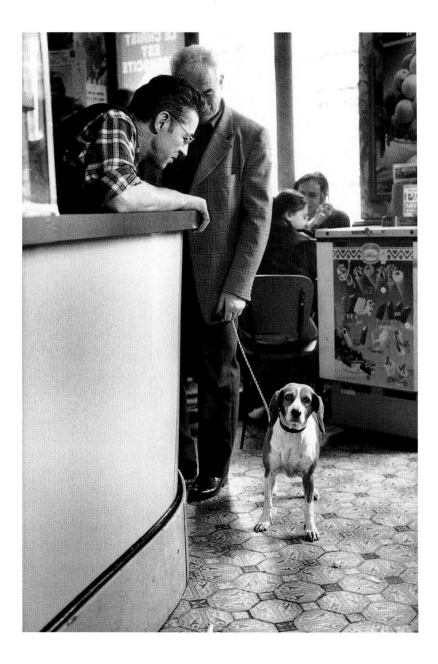

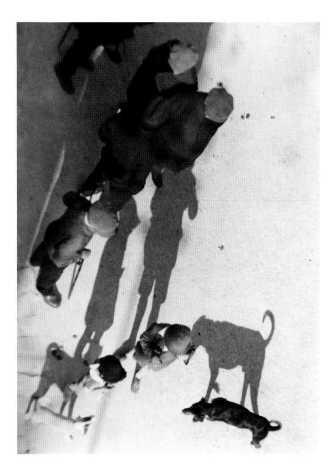

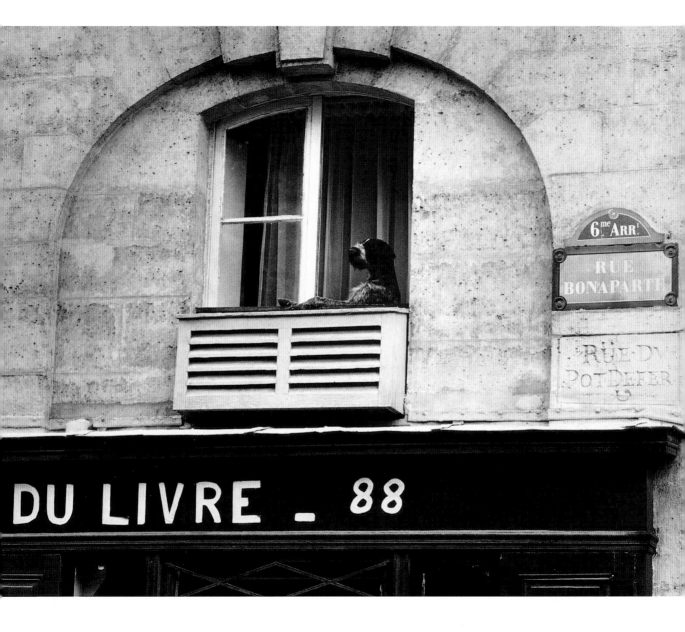

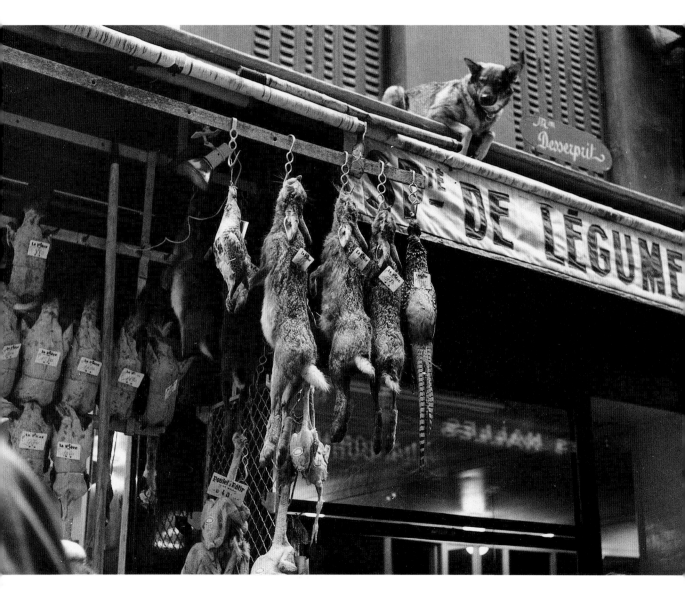

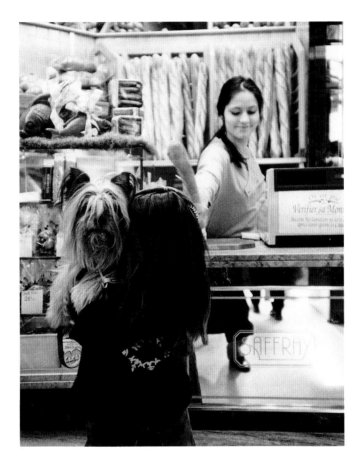

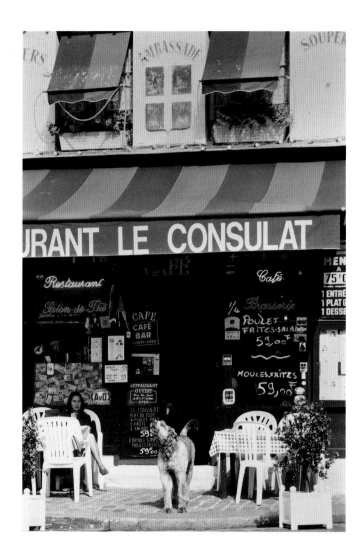

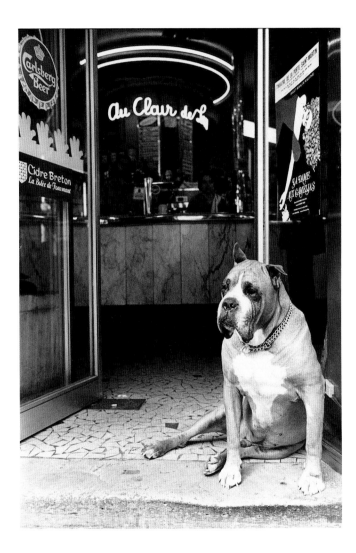

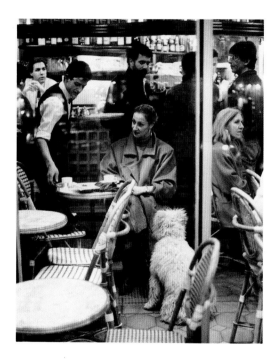

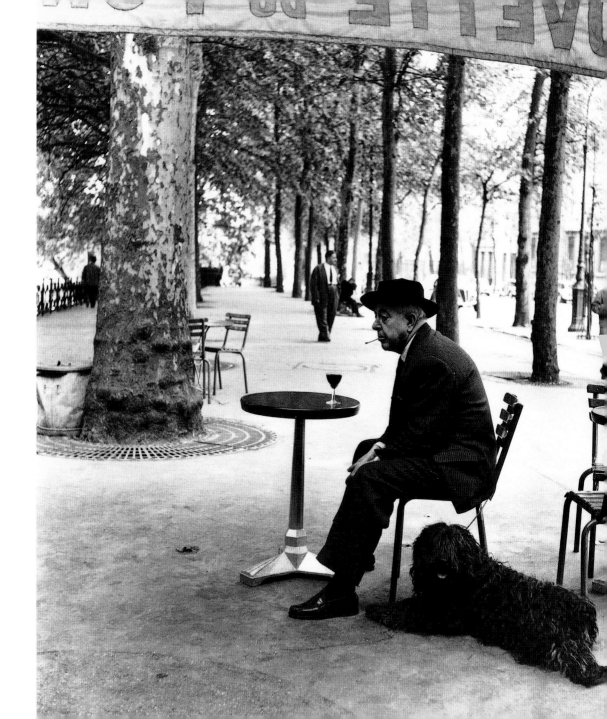

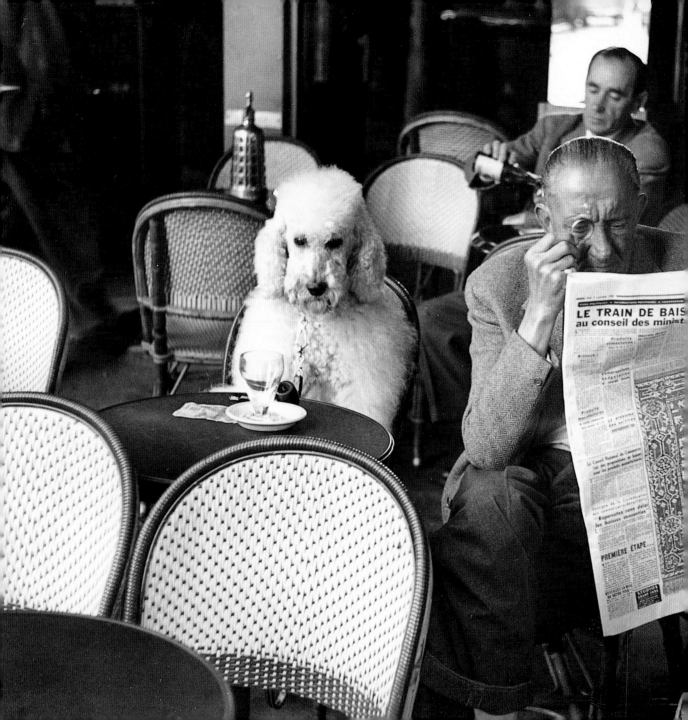

DOGS ARE
CERTAINLY LIKE THE
PEOPLE THAT OWN
THEM.
{ Gertrude Stein }

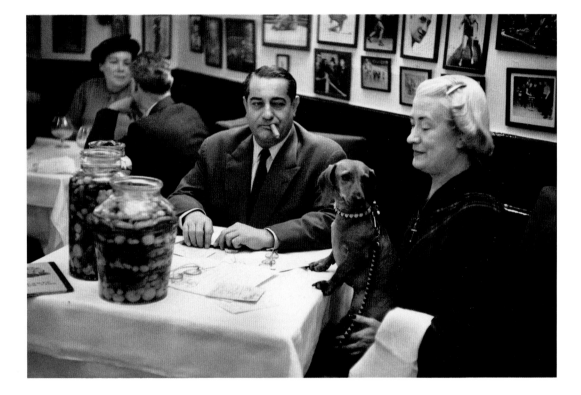

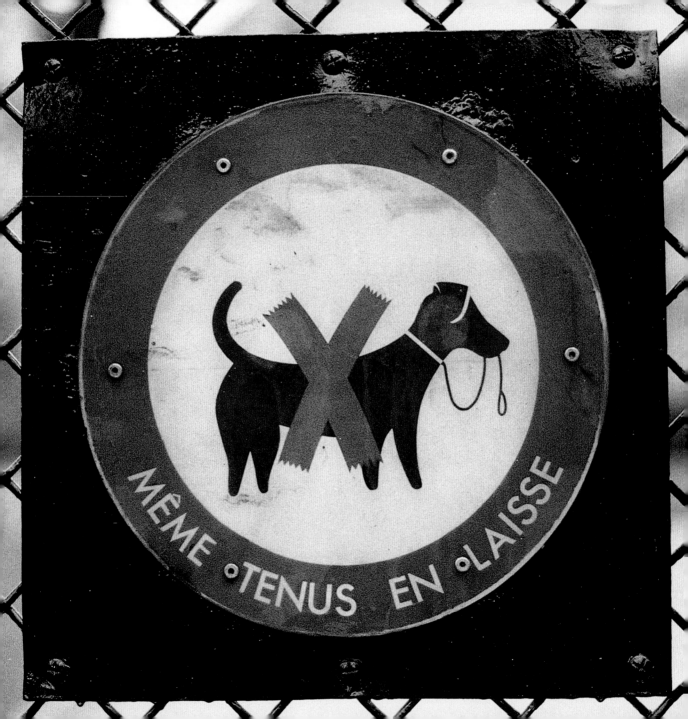

MÊME ·TENUS EN ·LAISSE

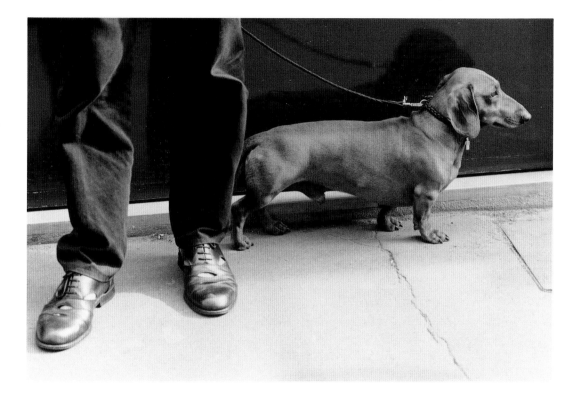

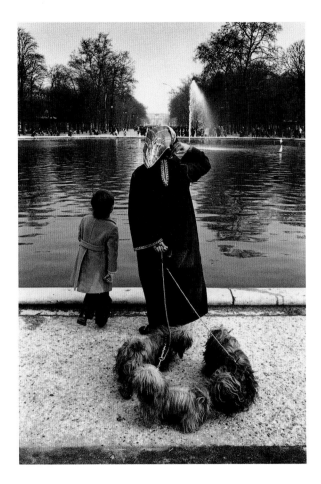

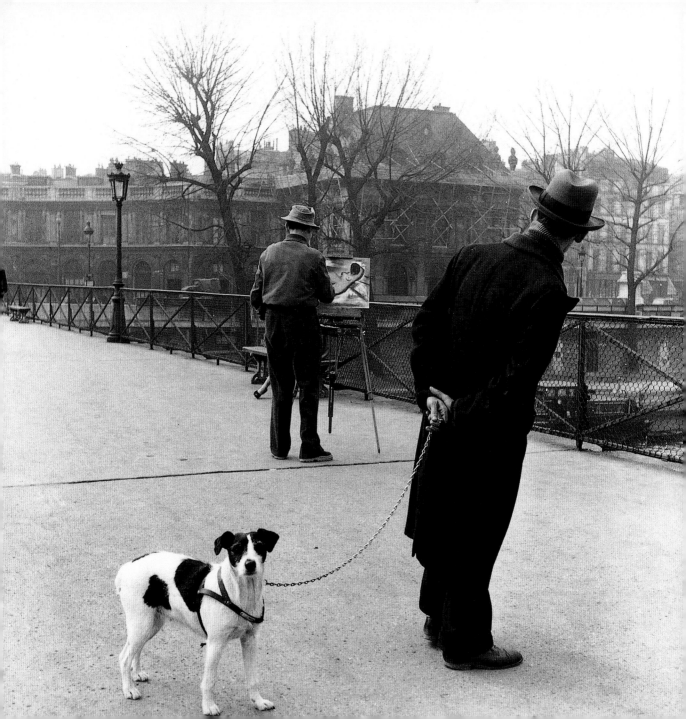

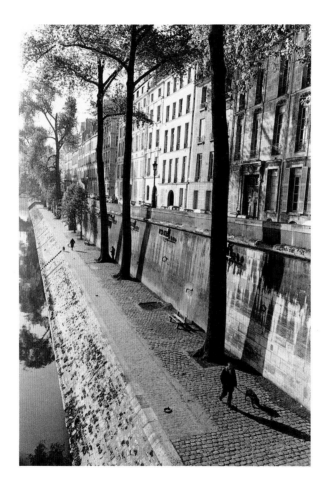

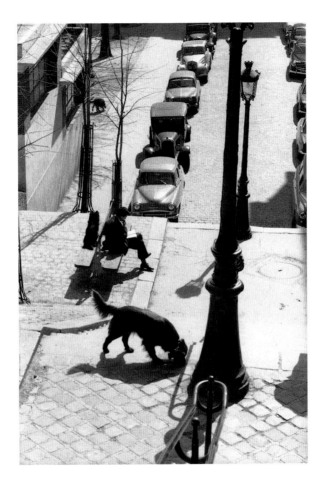

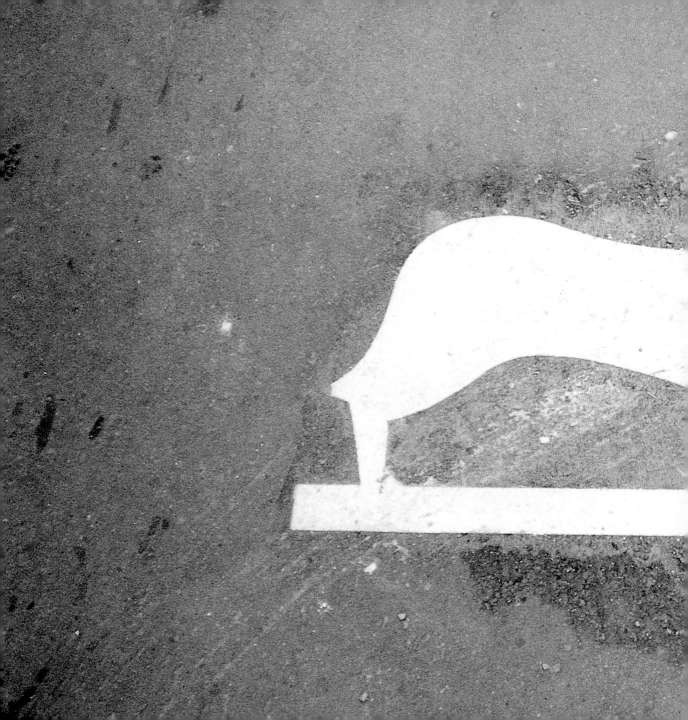

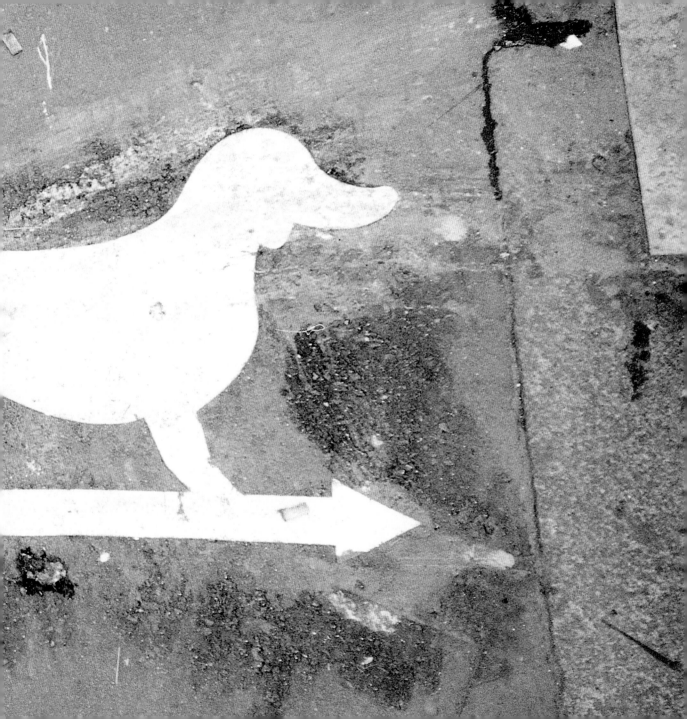

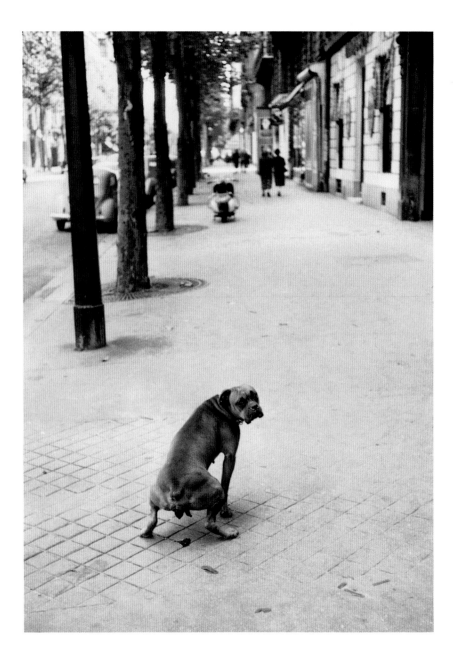

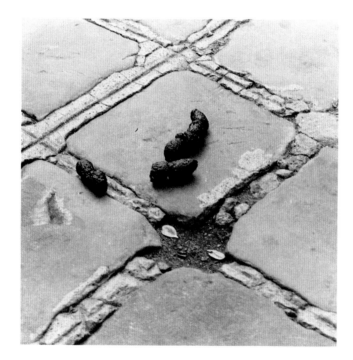

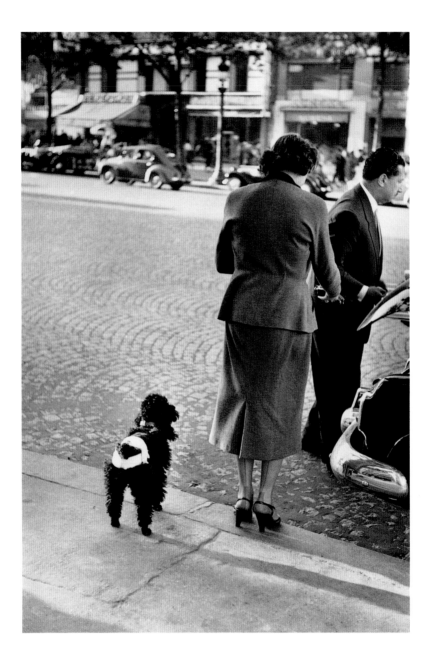

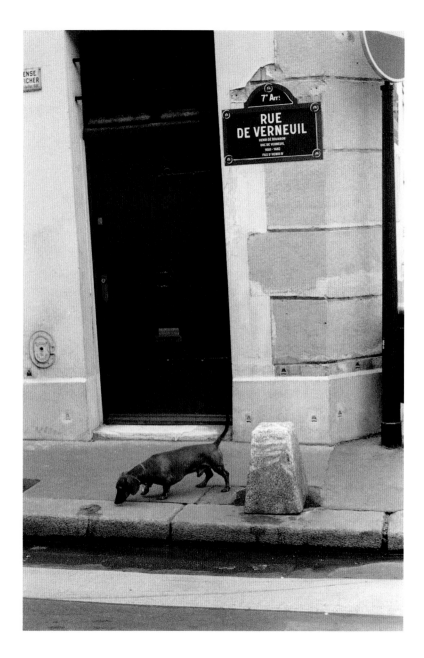

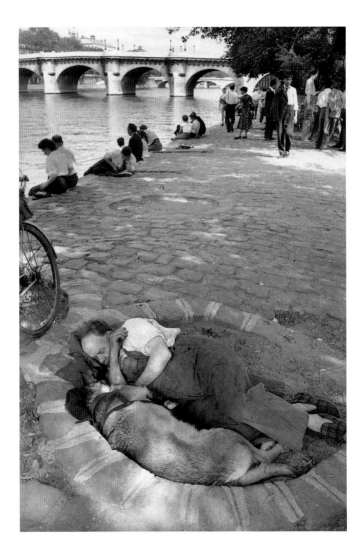

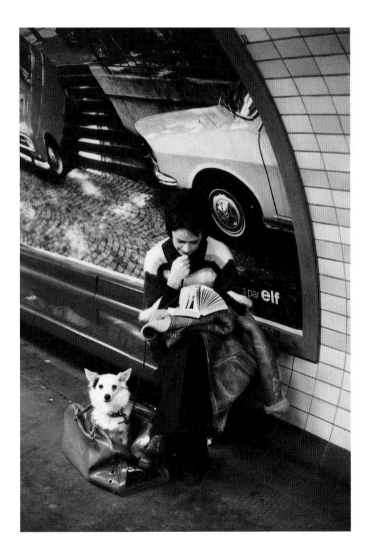

THE FRENCH DOG
OWNER SHARES HIS
PET'S HIGH OPINION
OF HIMSELF.
{Elliot Erwitt}

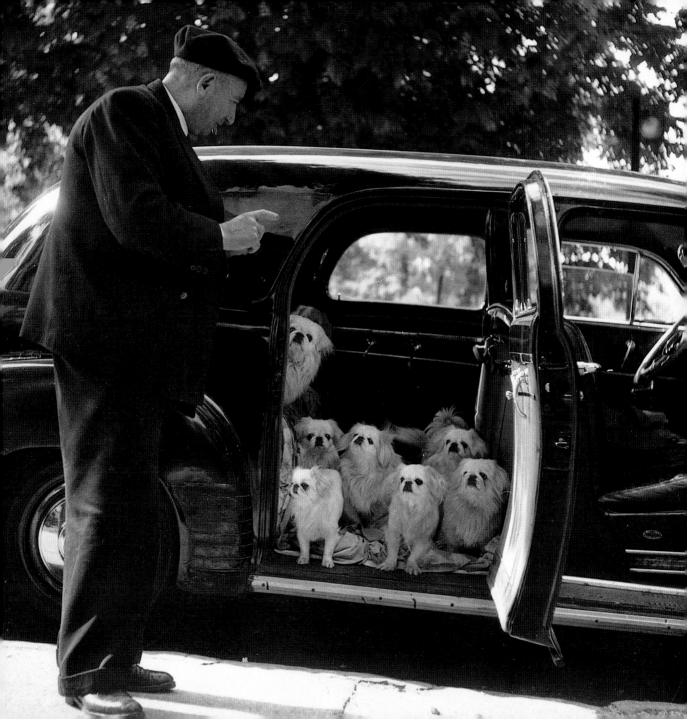

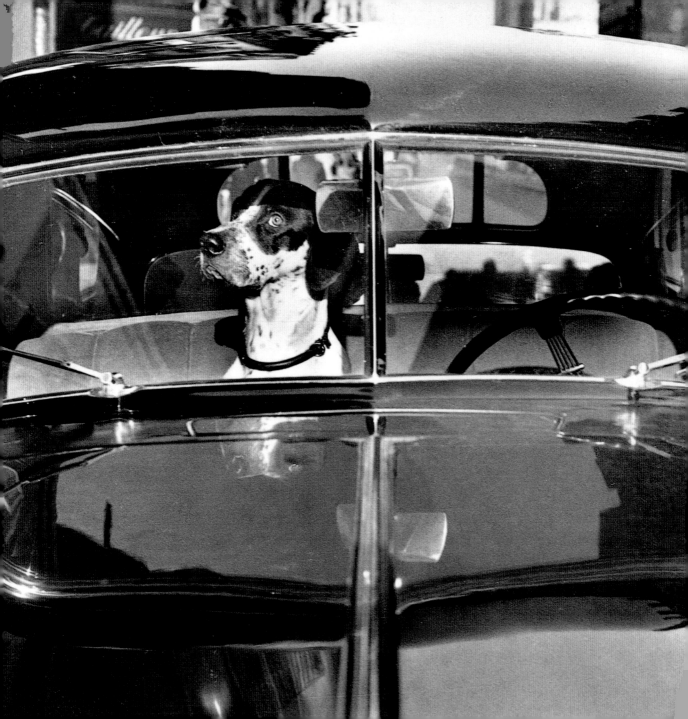

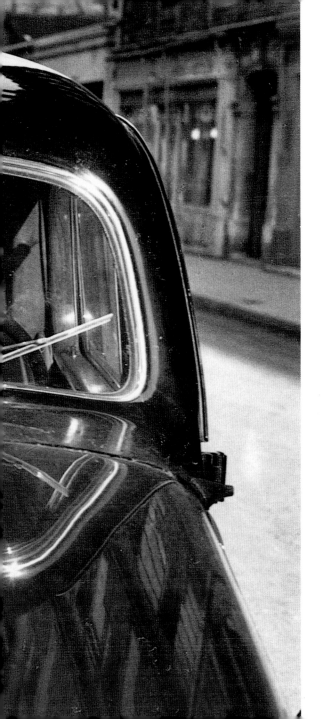

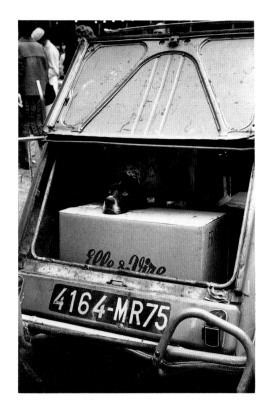

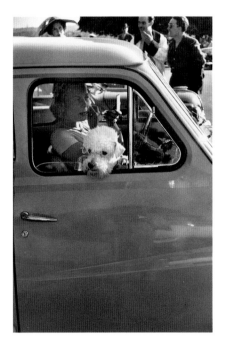

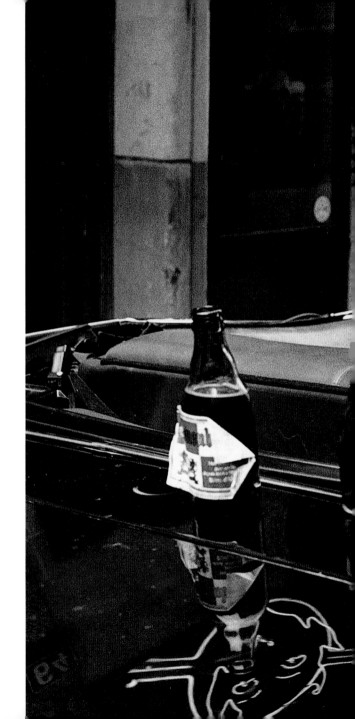

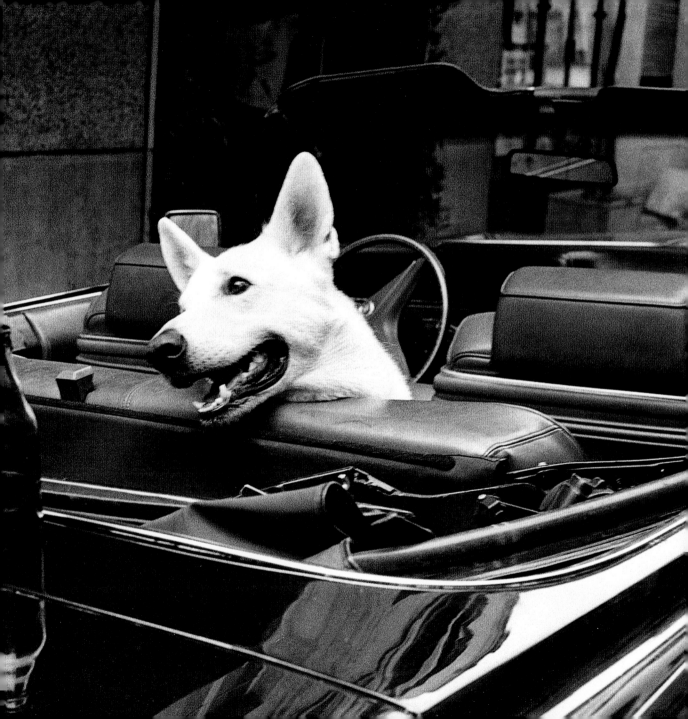

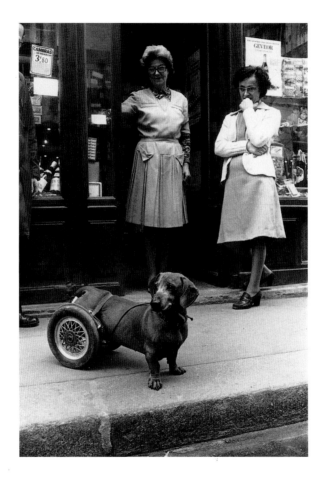

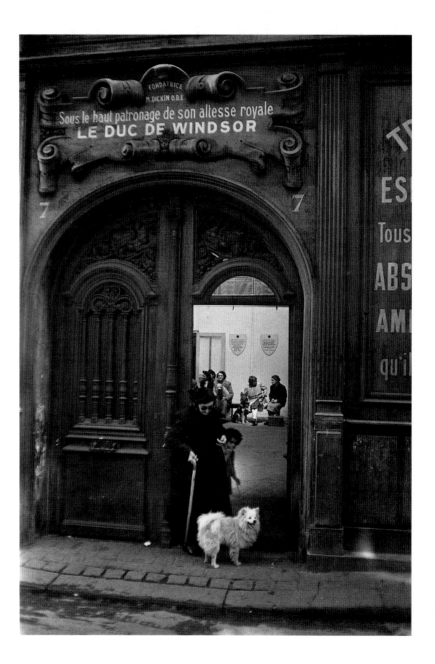

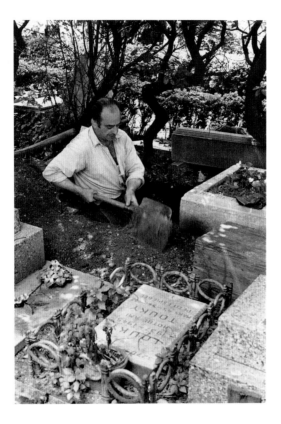

LES CHIENS
de Paris

{ Credits }

This book was designed by Jilly Simons with Susan Carlson at Concrete, Chicago, Illinois. The text was set in Bernhard Modern, designed by Lucian Bernhard, 1938, Chevalier, designed by E. A. Neukomm, 1946, and Cochin, designed by Matthew Carter, 1977, based on the original by Sol Hess, 1917. The book was printed in Singapore.